THIS JOL

MW00931915

Name:_____

Address:_____

Phone:_____ Cell:_____

email:_____

MMEGA PUBLISHING 2019

Cover: Andres Rodriquez, Canva Layouts.

HOW TO USE THIS NOTEBOOK

This Notebook/Journal gives you the <u>framework</u> for a Movie Lovers Adventure!!

Watch movies in any order.

Watch a movie then Critique it, using one of the MOVIE Critics Sheets.

The objective here is not to read an "Expects" opinion. The goal is of this Notebook/Journal is to give you the framework to "become the Expert".

What you get:

- o We have listed every winner from 1928-2019. Watch them in any order. Check them off as you proceed.
- o We have provided 91 Movie Critics Sheets to evaluate each movie.
- o After each 10 Critics Sheets we have included 'Best of Group' lined sheets for additional evaluation (information that will make it easier to make your final determination of Best of Best).
- o Finally, find blank 'Best of Group'lined journal pages at the end, to give you room to make your 'EXPERT OPINION', regarding your Best of Best Movie list choices.

Let the FUN Begin. Which movie will you watch first???

Oscar best picture winners List – 1928-2019

- [] 2019 - "Green Book"
- [] 2018 - "The Shape of Water"
- [] 2017 - "Moonlight"
- [] 2016 - "Spotlight"
- [] 2015 - "Birdman"
- [] 2014 - "12 Years a Slave"
- [] 2013 - "Argo"
- [] 2012 - "The Artist"
- [] 2011 - "The King's Speech"
- [] 2010 - "The Hurt Locker"
- [] 2009 - "Slumdog Millionaire"
- [] 2008 - "No Country for Old Men"
- [] 2007 - "The Departed"
- [] 2006 - "Crash"
- [] 2005 - "Million Dollar Baby"
- [] 2004 - "The Lord of the Rings: The Return of the King"

- [] 2003 - "Chicago"
- [] 2002 - "A Beautiful Mind"
- [] 2001 - "Gladiator"
- [] 2000 - "American Beauty"
- [] 1999 - "Shakespeare in Love"
- [] 1998 - "Titanic"
- [] 1997 - "The English Patient"
- [] 1996 - "Braveheart"
- [] 1995 - "Forrest Gump"
- [] 1994 - "Schindler's List"
- [] 1993 - "Unforgiven"
- [] 1992 - "The Silence of the Lambs"
- [] 1991 - "Dances With Wolves"
- [] 1990 - "Driving Miss Daisy"
- [] 1989 - "Rain Man"
- [] 1988 - "The Last Emperor"
- [] 1987 - "Platoon"

- [] 1986 - "Out of Africa"
- [] 1985 - "Amadeus"
- [] 1984 - "Terms of Endearment"
- [] 1983 - "Gandhi"
- [] 1982 - "Chariots of Fire"
- [] 1981 - "Ordinary People"
- [] 1980 - "Kramer vs. Kramer"
- [] 1979 - "The Deer Hunter"
- [] 1978 - "Annie Hall"
- [] 1977 - "Rocky"
- [] 1976 - "One Flew over the Cuckoo's Nest"
- [] 1975 - "The Godfather Part II"
- [] 1974 - "The Sting"
- [] 1973 - "The Godfather"
- [] 1972 - "The French Connection"
- [] 1971 - "Patton"
- [] 1970 - "Midnight Cowboy"
- [] 1969 - "Oliver!"

- [] 1968 - "In the Heat of the Night"
- [] 1967 - "A Man for All Seasons"
- [] 1966 - "The Sound of Music"
- [] 1965 - "My Fair Lady"
- [] 1964 - "Tom Jones"
- [] 1963 - "Lawrence of Arabia"
- [] 1962 - "West Side Story"
- [] 1961 - "The Apartment"
- [] 1960 - "Ben-Hur"
- [] 1959 - "Gigi"
- [] 1958 - "The Bridge on the River Kwai"
- [] 1957 - "Around the World in 80 Days"
- [] 1956 - "Marty"
- [] 1955 - "On the Waterfront"
- [] 1954 - "From Here to Eternity"
- [] 1953 - "The Greatest Show on Earth"
- [] 1952 - "An American in Paris"

- [] 1951 - "All About Eve"
- [] 1950 - "All the Kings Men"
- [] 1949 - "Hamlet"
- [] 1948 - "Gentleman's Agreement"
- [] 1947 - "The Best Years of Our Lives"
- [] 1946 - "The Lost Weekend"
- [] 1945 - "Going My Way"
- [] 1944 - "Casablanca"
- [] 1943 - "Mrs. Miniver"
- [] 1942 - "How Green Was My Valley"
- [] 1941 - "Rebecca"
- [] 1940 - "Gone with the Wind"

- [] 1939 - "You Can't Take It with You"
- [] 1938 - "The Life of Emile Zola"
- [] 1937 - "The Great Ziegfeld"
- [] 1936 - "Mutiny on the Bounty"
- [] 1935 - "It Happened One Night"
- [] 1933/1934 - "Cavalcade"
- [] 1932/1933 - "Grand Hotel"
- [] 1931/1932 - "Cimarron"
- [] 1930/1931 - "All Quiet on the Western Front"
- [] 1929/1930 - "The Broadway Melody"
- [] 1928/1929 - "Wings"

MOVIE Critic Sheet

Movie:

Director: Studio:

Cast:

Award Date: Genre:

Plot:

Quotes:

Thoughts:

Rated	Rating	Page #
	☆☆☆☆☆	

MOVIE Critic Sheet

Movie:

Director: Studio:

Cast:

Award Date: Genre:

Plot:

Quotes:

Thoughts:

Rated	Rating	Page #
	☆☆☆☆☆	

MOVIE Critic Sheet

Movie:

Director: Studio:

Cast:

Award Date: Genre:

Plot:

Quotes:

Thoughts:

Rated	Rating	Page #
	☆☆☆☆☆	

MOVIE Critic Sheet

Movie:

Director:

Studio:

Cast:

Award Date:

Genre:

Plot:

Quotes:

Thoughts:

Rated	Rating	Page #
	☆☆☆☆☆	

MOVIE Critic Sheet

Movie:

Director: Studio:

Cast:

Award Date: Genre:

Plot:

Quotes:

Thoughts:

Rated	Rating	Page #
	☆☆☆☆☆	

MOVIE Critic Sheet

Movie:

Director: Studio:

Cast:

Award Date: Genre:

Plot:

Quotes:

Thoughts:

Rated	Rating	Page #
	☆☆☆☆☆	

MOVIE Critic Sheet

Movie:

Director:

Studio:

Cast:

Award Date:

Genre:

Plot:

Quotes:

Thoughts:

Rated	Rating	Page #
	☆☆☆☆☆	

MOVIE Critic Sheet

Movie:

Director: Studio:

Cast:

Award Date: Genre:

Plot:

Quotes:

Thoughts:

Rated	Rating	Page #
	☆☆☆☆☆	

MOVIE Critic Sheet

Movie:

Director: Studio:

Cast:

Award Date: Genre:

Plot:

Quotes:

Thoughts:

Rated	Rating	Page #
	☆☆☆☆☆	

MOVIE Critic Sheet

Movie:

Director: Studio:

Cast:

Award Date: Genre:

Plot:

Quotes:

Thoughts:

Rated	Rating	Page #
	☆☆☆☆☆	

BEST OF GROUP AND WHY

BEST OF GROUP AND WHY

MOVIE Critic Sheet

Movie:

Director: Studio:

Cast:

Award Date: Genre:

Plot:

Quotes:

Thoughts:

Rated	Rating	Page #
	☆☆☆☆☆	

MOVIE Critic Sheet

Movie:

Director:

Studio:

Cast:

Award Date:

Genre:

Plot:

Quotes:

Thoughts:

Rated	Rating	Page #
	☆☆☆☆☆	

MOVIE Critic Sheet

Movie:

Director: Studio:

Cast:

Award Date: Genre:

Plot:

Quotes:

Thoughts:

Rated	Rating	Page #
	☆☆☆☆☆	

MOVIE Critic Sheet

Movie:

Director:

Studio:

Cast:

Award Date:

Genre:

Plot:

Quotes:

Thoughts:

Rated	Rating	Page #
	☆☆☆☆☆	

MOVIE Critic Sheet

Movie:

Director:

Studio:

Cast:

Award Date:

Genre:

Plot:

Quotes:

Thoughts:

Rated	Rating	Page #
	☆☆☆☆☆	

MOVIE Critic Sheet

Movie:

Director: Studio:

Cast:

Award Date: Genre:

Plot:

Quotes:

Thoughts:

Rated	Rating	Page #
	☆☆☆☆☆	

MOVIE Critic Sheet

Movie:

Director: Studio:

Cast:

Award Date: Genre:

Plot:

Quotes:

Thoughts:

Rated	Rating	Page #
	☆☆☆☆☆	

MOVIE Critic Sheet

Movie:

Director: Studio:

Cast:

Award Date: Genre:

Plot:

Quotes:

Thoughts:

Rated	Rating	Page #
	☆☆☆☆☆	

MOVIE Critic Sheet

Movie:

Director: | Studio:

Cast:

Award Date: | Genre:

Plot:

Quotes:

Thoughts:

Rated	Rating	Page #
	☆☆☆☆☆	

MOVIE Critic Sheet

Movie:

Director:

Studio:

Cast:

Award Date:

Genre:

Plot:

Quotes:

Thoughts:

Rated	Rating	Page #
	☆☆☆☆☆	

BEST OF GROUP AND WHY

BEST OF GROUP AND WHY

MOVIE Critic Sheet

Movie:

Director: Studio:

Cast:

Award Date: Genre:

Plot:

Quotes:

Thoughts:

Rated	Rating	Page #
	☆☆☆☆☆	

MOVIE Critic Sheet

Movie:

Director: Studio:

Cast:

Award Date: Genre:

Plot:

Quotes:

Thoughts:

Rated	Rating	Page #
	☆☆☆☆☆	

MOVIE Critic Sheet

Movie:

Director: | **Studio:**

Cast:

Award Date: | **Genre:**

Plot:

Quotes:

Thoughts:

Rated	Rating	Page #
	☆☆☆☆☆	

MOVIE Critic Sheet

Movie:

Director:

Studio:

Cast:

Award Date:

Genre:

Plot:

Quotes:

Thoughts:

Rated	Rating	Page #
	☆☆☆☆☆	

MOVIE Critic Sheet

Movie:

Director: Studio:

Cast:

Award Date: Genre:

Plot:

Quotes:

Thoughts:

Rated	Rating	Page #
	☆☆☆☆☆	

MOVIE Critic Sheet

Movie:

Director:

Studio:

Cast:

Award Date:

Genre:

Plot:

Quotes:

Thoughts:

Rated	Rating	Page #
	☆☆☆☆☆	

MOVIE Critic Sheet

Movie:

Director:

Studio:

Cast:

Award Date:

Genre:

Plot:

Quotes:

Thoughts:

Rated	Rating	Page #
	☆☆☆☆☆	

MOVIE Critic Sheet

Movie:

Director: **Studio:**

Cast:

Award Date: **Genre:**

Plot:

Quotes:

Thoughts:

Rated	Rating	Page #
	☆☆☆☆☆	

MOVIE Critic Sheet

Movie:

Director: | **Studio:**

Cast:

Award Date: | **Genre:**

Plot:

Quotes:

Thoughts:

Rated	Rating	Page #
	☆☆☆☆☆	

MOVIE Critic Sheet

Movie:

Director:

Studio:

Cast:

Award Date:

Genre:

Plot:

Quotes:

Thoughts:

Rated

Rating

☆☆☆☆☆

Page #

BEST OF GROUP AND WHY

BEST OF GROUP AND WHY

MOVIE Critic Sheet

Movie:

Director: Studio:

Cast:

Award Date: Genre:

Plot:

Quotes:

Thoughts:

Rated	Rating	Page #
	☆☆☆☆☆	

MOVIE Critic Sheet

Movie:

Director: Studio:

Cast:

Award Date: Genre:

Plot:

Quotes:

Thoughts:

Rated	Rating	Page #
	☆☆☆☆☆	

MOVIE Critic Sheet

Movie:

Director: | Studio:

Cast:

Award Date: | Genre:

Plot:

Quotes:

Thoughts:

Rated	Rating	Page #
	☆☆☆☆☆	

MOVIE Critic Sheet

Movie:

Director: Studio:

Cast:

Award Date: Genre:

Plot:

Quotes:

Thoughts:

Rated Rating Page #

☆☆☆☆☆

MOVIE Critic Sheet

Movie:

Director: | Studio:

Cast:

Award Date: | Genre:

Plot:

Quotes:

Thoughts:

Rated	Rating	Page #
	☆☆☆☆☆	

MOVIE Critic Sheet

Movie:

Director: Studio:

Cast:

Award Date: Genre:

Plot:

Quotes:

Thoughts:

Rated	Rating	Page #
	☆☆☆☆☆	

MOVIE Critic Sheet

Movie:

Director: Studio:

Cast:

Award Date: Genre:

Plot:

Quotes:

Thoughts:

Rated	Rating	Page #
	☆☆☆☆☆	

MOVIE Critic Sheet

Movie:

Director: Studio:

Cast:

Award Date: Genre:

Plot:

Quotes:

Thoughts:

Rated	Rating	Page #
	☆☆☆☆☆	

MOVIE Critic Sheet

Movie:

Director:

Studio:

Cast:

Award Date:

Genre:

Plot:

Quotes:

Thoughts:

Rated	Rating	Page #
	☆☆☆☆☆	

MOVIE Critic Sheet

Movie:

Director: | Studio:

Cast:

Award Date: | Genre:

Plot:

Quotes:

Thoughts:

| Rated | Rating | Page # |

☆☆☆☆☆

BEST OF GROUP AND WHY

BEST OF GROUP AND WHY

MOVIE Critic Sheet

Movie:

Director: Studio:

Cast:

Award Date: Genre:

Plot:

Quotes:

Thoughts:

Rated	Rating	Page #
	☆☆☆☆☆	

MOVIE Critic Sheet

Movie:

Director: Studio:

Cast:

Award Date: Genre:

Plot:

Quotes:

Thoughts:

Rated	Rating	Page #
	☆☆☆☆☆	

MOVIE Critic Sheet

Movie:

Director: Studio:

Cast:

Award Date: Genre:

Plot:

Quotes:

Thoughts:

Rated	Rating	Page #
	☆☆☆☆☆	

MOVIE Critic Sheet

Movie:

Director: Studio:

Cast:

Award Date: Genre:

Plot:

Quotes:

Thoughts:

Rated	Rating	Page #
	☆☆☆☆☆	

MOVIE Critic Sheet

Movie:

Director: Studio:

Cast:

Award Date: Genre:

Plot:

Quotes:

Thoughts:

Rated	Rating	Page #
	☆☆☆☆☆	

MOVIE Critic Sheet

Movie:

Director: Studio:

Cast:

Award Date: Genre:

Plot:

Quotes:

Thoughts:

Rated	Rating	Page #
	☆☆☆☆☆	

MOVIE Critic Sheet

Movie:

Director: | Studio:

Cast:

Award Date: | Genre:

Plot:

Quotes:

Thoughts:

Rated	Rating	Page #
	☆☆☆☆☆	

MOVIE Critic Sheet

Movie:

Director: Studio:

Cast:

Award Date: Genre:

Plot:

Quotes:

Thoughts:

Rated	Rating	Page #
	☆☆☆☆☆	

MOVIE Critic Sheet

Movie:

Director: Studio:

Cast:

Award Date: Genre:

Plot:

Quotes:

Thoughts:

Rated	Rating	Page #
	☆☆☆☆☆	

MOVIE Critic Sheet

Movie:

Director: Studio:

Cast:

Award Date: Genre:

Plot:

Quotes:

Thoughts:

Rated	Rating	Page #
	☆☆☆☆☆	

BEST OF GROUP AND WHY

BEST OF GROUP AND WHY

MOVIE Critic Sheet

Movie:

Director: Studio:

Cast:

Award Date: Genre:

Plot:

Quotes:

Thoughts:

Rated	Rating	Page #
	☆☆☆☆☆	

MOVIE Critic Sheet

Movie:

Director: Studio:

Cast:

Award Date: Genre:

Plot:

Quotes:

Thoughts:

Rated	Rating	Page #
	☆☆☆☆☆	

MOVIE Critic Sheet

Movie:

Director: Studio:

Cast:

Award Date: Genre:

Plot:

Quotes:

Thoughts:

Rated	Rating	Page #
	☆☆☆☆☆	

MOVIE Critic Sheet

Movie:

Director: Studio:

Cast:

Award Date: Genre:

Plot:

Quotes:

Thoughts:

Rated	Rating	Page #
	☆☆☆☆☆	

MOVIE Critic Sheet

Movie:

Director: Studio:

Cast:

Award Date: Genre:

Plot:

Quotes:

Thoughts:

Rated	Rating	Page #
	☆☆☆☆☆	

MOVIE Critic Sheet

Movie:

Director: Studio:

Cast:

Award Date: Genre:

Plot:

Quotes:

Thoughts:

Rated	Rating	Page #
	☆☆☆☆☆	

MOVIE Critic Sheet

Movie:

Director: Studio:

Cast:

Award Date: Genre:

Plot:

Quotes:

Thoughts:

Rated	Rating	Page #
	☆☆☆☆☆	

MOVIE Critic Sheet

Movie:

Director: Studio:

Cast:

Award Date: Genre:

Plot:

Quotes:

Thoughts:

Rated	Rating	Page #
	☆☆☆☆☆	

MOVIE Critic Sheet

Movie:

Director: | Studio:

Cast:

Award Date: | Genre:

Plot:

Quotes:

Thoughts:

Rated	Rating	Page #
	☆☆☆☆☆	

MOVIE Critic Sheet

Movie:

Director: | Studio:

Cast:

Award Date: | Genre:

Plot:

Quotes:

Thoughts:

Rated	Rating	Page #
	☆☆☆☆☆	

BEST OF GROUP AND WHY

BEST OF GROUP AND WHY

MOVIE Critic Sheet

Movie:

Director: Studio:

Cast:

Award Date: Genre:

Plot:

Quotes:

Thoughts:

Rated	Rating	Page #
	☆☆☆☆☆	

MOVIE Critic Sheet

Movie:

Director: Studio:

Cast:

Award Date: Genre:

Plot:

Quotes:

Thoughts:

Rated	Rating	Page #
	☆☆☆☆☆	

MOVIE Critic Sheet

Movie:

Director: | Studio:

Cast:

Award Date: | Genre:

Plot:

Quotes:

Thoughts:

Rated	Rating	Page #
	☆☆☆☆☆	

MOVIE Critic Sheet

Movie:

Director: Studio:

Cast:

Award Date: Genre:

Plot:

Quotes:

Thoughts:

Rated	Rating	Page #
	☆☆☆☆☆	

MOVIE Critic Sheet

Movie:

Director: Studio:

Cast:

Award Date: Genre:

Plot:

Quotes:

Thoughts:

Rated	Rating	Page #
	☆☆☆☆☆	

MOVIE Critic Sheet

Movie:

Director: | Studio:

Cast:

Award Date: | Genre:

Plot:

Quotes:

Thoughts:

Rated	Rating	Page #
	☆☆☆☆☆	

MOVIE Critic Sheet

Movie:

Director: | Studio:

Cast:

Award Date: | Genre:

Plot:

Quotes:

Thoughts:

Rated	Rating	Page #
	☆☆☆☆☆	

MOVIE Critic Sheet

Movie:

Director:

Studio:

Cast:

Award Date:

Genre:

Plot:

Quotes:

Thoughts:

Rated	Rating	Page #
	☆☆☆☆☆	

MOVIE Critic Sheet

Movie:

Director: Studio:

Cast:

Award Date: Genre:

Plot:

Quotes:

Thoughts:

Rated	Rating	Page #
	☆☆☆☆☆	

MOVIE Critic Sheet

Movie:

Director: Studio:

Cast:

Award Date: Genre:

Plot:

Quotes:

Thoughts:

Rated	Rating	Page #
	☆☆☆☆☆	

BEST OF GROUP AND WHY

BEST OF GROUP AND WHY

MOVIE Critic Sheet

Movie:

Director: | Studio:

Cast:

Award Date: | Genre:

Plot:

Quotes:

Thoughts:

Rated	Rating	Page #
	☆☆☆☆☆	

MOVIE Critic Sheet

Movie:

Director:

Studio:

Cast:

Award Date:

Genre:

Plot:

Quotes:

Thoughts:

Rated	Rating	Page #
	☆☆☆☆☆	

MOVIE Critic Sheet

Movie:

Director: | Studio:

Cast:

Award Date: | Genre:

Plot:

Quotes:

Thoughts:

Rated	Rating	Page #
	☆☆☆☆☆	

MOVIE Critic Sheet

Movie:

Director: Studio:

Cast:

Award Date: Genre:

Plot:

Quotes:

Thoughts:

Rated Rating Page #

☆☆☆☆☆

MOVIE Critic Sheet

Movie:

Director: Studio:

Cast:

Award Date: Genre:

Plot:

Quotes:

Thoughts:

Rated	Rating	Page #
	☆☆☆☆☆	

MOVIE Critic Sheet

Movie:

Director: | Studio:

Cast:

Award Date: | Genre:

Plot:

Quotes:

Thoughts:

Rated	Rating	Page #
	☆☆☆☆☆	

MOVIE Critic Sheet

Movie:

Director: Studio:

Cast:

Award Date: Genre:

Plot:

Quotes:

Thoughts:

Rated	Rating	Page #
	☆☆☆☆☆	

MOVIE Critic Sheet

Movie:

Director: Studio:

Cast:

Award Date: Genre:

Plot:

Quotes:

Thoughts:

Rated	Rating	Page #
	☆☆☆☆☆	

MOVIE Critic Sheet

Movie:

Director: | Studio:

Cast:

Award Date: | Genre:

Plot:

Quotes:

Thoughts:

Rated	Rating	Page #
	☆☆☆☆☆	

MOVIE Critic Sheet

Movie:

Director: Studio:

Cast:

Award Date: Genre:

Plot:

Quotes:

Thoughts:

Rated	Rating	Page #
	☆☆☆☆☆	

BEST OF GROUP AND WHY

BEST OF GROUP AND WHY

MOVIE Critic Sheet

Movie:

Director: | Studio:

Cast:

Award Date: | Genre:

Plot:

Quotes:

Thoughts:

Rated	Rating	Page #
	☆☆☆☆☆	

MOVIE Critic Sheet

Movie:

Director: Studio:

Cast:

Award Date: Genre:

Plot:

Quotes:

Thoughts:

Rated	Rating	Page #
	☆☆☆☆☆	

MOVIE Critic Sheet

Movie:

Director: Studio:

Cast:

Award Date: Genre:

Plot:

Quotes:

Thoughts:

Rated	Rating	Page #
	☆☆☆☆☆	

MOVIE Critic Sheet

Movie:

Director: Studio:

Cast:

Award Date: Genre:

Plot:

Quotes:

Thoughts:

| Rated | Rating ☆☆☆☆☆ | Page # |

MOVIE Critic Sheet

Movie:

Director: Studio:

Cast:

Award Date: Genre:

Plot:

Quotes:

Thoughts:

Rated	Rating	Page #
	☆☆☆☆☆	

MOVIE Critic Sheet

Movie:

Director: Studio:

Cast:

Award Date: Genre:

Plot:

Quotes:

Thoughts:

Rated	Rating	Page #
	☆☆☆☆☆	

MOVIE Critic Sheet

Movie:

Director: Studio:

Cast:

Award Date: Genre:

Plot:

Quotes:

Thoughts:

Rated	Rating	Page #
	☆☆☆☆☆	

MOVIE Critic Sheet

Movie:

Director: Studio:

Cast:

Award Date: Genre:

Plot:

Quotes:

Thoughts:

Rated	Rating	Page #
	☆☆☆☆☆	

MOVIE Critic Sheet

Movie:

Director: | Studio:

Cast:

Award Date: | Genre:

Plot:

Quotes:

Thoughts:

Rated	Rating	Page #
	☆☆☆☆☆	

MOVIE Critic Sheet

Movie:

Director: Studio:

Cast:

Award Date: Genre:

Plot:

Quotes:

Thoughts:

Rated Rating Page #

☆☆☆☆☆

MOVIE Critic Sheet

Movie:

Director: | Studio:

Cast:

Award Date: | Genre:

Plot:

Quotes:

Thoughts:

Rated	Rating	Page #
	☆☆☆☆☆	

BEST OF GROUP AND WHY

BEST OF GROUP AND WHY

BEST OF GROUP AND WHY

Made in the USA
Coppell, TX
28 February 2020